REX

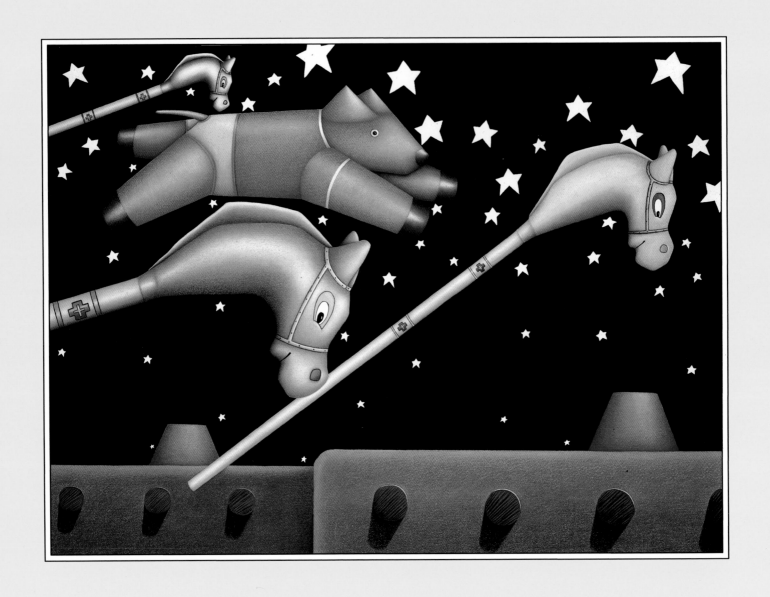

"Rex entered Santa Fe with Dream Ponies
Maurice, Desmond, and Lou."

REX

by

VAN DYKE JONES

NORTHLAND

PUBLISHING

For information, address
Northland Publishing Co., Inc.,
P. O. Box N, Flagstaff, AZ 86002

First Edition

Softcover ISBN 0-87358-512-7
Hardcover ISBN 0-87358-514-3
Library of Congress
Catalog Card Number
90-41614

Library of Congress Cataloging-in-Publication Data

Jones Van Dyke.
Rex / Van Dyke Jones. — 1st ed.
104 p.
ISBN 0-87358-514-3; — ISBN 0-87358-512-7 (pbk.) : $16.95
I. Jones, Van Dyke—Themes, motives. I. Title.
ND237.J765A4 1990
759.13—dc20 90-41614
CIP

Designed by
Larry Lindahl

Manufactured in
Singapore by Saik Wah Press

For my mother Betty; my wife Stephanie; my daughter Audrey;
and my friends Earl Parker, Frank Howell, Larry Fodor,
Peter Schuyler, and Bill Lagattuta for their moral and financial
support over the years.

Introduction

Whether at a formal opening or on being introduced to a prospective client while I'm prowling through the gallery praying to God a painting sells, there is usually one question that is always asked: "Where did you come up with the idea of Rex?"

I wonder a lot about that myself. Sometimes I think Rex came up with me. Now, that's strictly between you and I, dear reader. So you don't need to go running off, telling your friends who don't have the book that the guy who paints the funny little dog might really be a trifle unbalanced. Many people have had that idea before you—it's not like it's a big secret. I'm just trying to share private thoughts from the studio with you.

Actually, Rex came about in the form of a doodle. The kind of doodle you do sometimes when you're at a job trying to keep from falling asleep upon arriving at work after driving through a snow storm and the boss calls and explains that he won't be coming in on account of the weather. Then gives you a list of must-dos that take all of twenty minutes, leaving you with seven hours and forty minutes to yourself, during which time you can imitate the fungus in your refrigerator or imagine what it would be like if you were the last person on earth. (Then there is always the phone doodle to be considered. Which, of course, is the only doodle the majority of us will testify to actually doing.)

This doodling went on for a couple of years while I was busy working at a regular job in the day and devoting the night and the better part of the early morning to another entirely different body of artwork. This body of work consisted mainly of fish. Now, these weren't paintings of fish for sportsmen . . . they were isolated details of fish, or fish swimming on or off the page. They were anatomically correct and were accompanied by notes and information on the fish, or letters to friends from a ficticious biological illustrator in the field, or maybe a shopping list.

During this time my wife Stephanie was pregnant with our daughter Audrey. It was shortly after Audrey's birth that I got the idea to paint images that I thought would be pleasant for my daughter to look at, plus fun images with which to identify "Dad." I stayed up one night and finished a 30" × 40" color drawing of the doodle that would later be known as "Rex" on a piece of four-ply foam core.

I felt as though I had always known this shape. At first, I thought it was just me, but the more I showed it around, the more apparent it became that the shape also appealed to others, and they too seemed to understand it. How or why is speculation. I knew from the first Rex I drew that this was the character I wanted to explore in my paintings.

Rex was perfect for me. He provided a vehicle that was fun to paint. I could put him in different settings, in different situations . . . he could go anywhere and do anything. I could continue to write on the pieces as I was doing with the fish illustrations. Then, an interesting thing occurred. Slowly but surely, Rex's personality started to unfold. Now, a lot of people who see Rex identify with him almost immediately. It has been said more than once that Rex is a direct reflection of myself, an alter ego. It's probably true. It would be easy to make that assumption. Since I am the creator, or created, depending on who you talked to first, Rex, or myself. But I think it goes further than that.

I see Rex as "Everyman," much like the central characters in James Thurber's stories, "Blondie and Dagwood," "Bringing Up Father," or "Pogo." Through Rex, I'm able to examine those little quirks, pleasures, insecurities, skepticisms, and sensitivities that are innate in each of us. I find it very healthy to portray, with humor and honesty, these facets of the individual common to us all.

About the origin of the name Rex. There was never any conscious effort made in the selection of his name, but recently I have remembered an event from my childhood that gives some insight into that particular choice.

When I was nine or ten years old, the grocery store where my family always shopped was raffling off a pony. Like almost every child growing up in the Midwest, it was my dream to have a pony of my very own. I had visions of the two of us being inseparable friends. (This fantasy was no doubt due to watching too many episodes of "My Friend Flicka" and "Fury," two popular television programs of that period.) Back then, it was as common for a child to have a pony as to have a dog.

Well, anyway, each week I would faithfully fill out the raffle slips. Then, one morning, my mother woke me up earlier than usual. She told me to hurry and get dressed and to go out and wait for her in the car because I'd won the pony. You can't imagine my excitement as I dressed. I saw myself as a young cowpoke. Out in the car, I started thinking of name for my new best friend. Rex was one of the names I remember as being at the top of my list. A great deal of time seemed to pass. I looked up at the house to see what

was taking my parents so long. There, in the picture window, were both Mom and Dad watching me and trying to hold their laughter. Unsuspecting, I decided to go back in and hurry them along. I walked into the living room and they both shouted ''April fool's!'' It was April first.

Rex, it would seem, is the pony I never had. (I tend to believe that I have been bound and determined to name something ''Rex'' since a very early age. It wouldn't surprise me in the least to find out that until that point all my pets had been named Rex.)

By the way, in defense of my mother's seemingly cruel joke, I would like to explain that, as a child, I was somewhat of an habitual practical joker. My favorite joke for about a month was to creep up behind my mother while she vacuumed and, in the deepest voice I could muster, sing the theme song from ''Rawhide.'' For some reason, I thought it was great fun to watch my mother fly straight up out of her flip-flops. Her only defense against such an odd child was a strong offense, and I soon found out that she knew how to play this game just as well, if not better, than I did.

The names generally used for the characters in the canvases and lithographs are all totally made up. Meaning I don't have any friends or relatives that go by any of those names. I know no Milt and Wendelin Johnson, Rodney, Harlan, Raphael, Desmond, Maurice, Lou, Polly, or Paloma. Pardon me, I *do* know a Paloma now. She's two years old but she wasn't born until after I had been using the name for Rex's daughter for a couple of years.

It would be easier to pull from a whole host of names of relatives: Elmer, Hattie, Gladys, Mable, Dillard, Nute, Zelda, Bootsy, or Peter Bob. All but Peter Bob were relatives. Peter Bob was one of my pet rabbits.

At times I'm asked if the stories are autobiographical. In a sense they are, but I tend to select the stories that reflect a common thread shared by all. No doubt the same circumstances that structure the tales I use were happening five hundred years ago. Man's relationship to wife and family, man's relationship with himself, man's relationship with this environment, and on and on. Except for perhaps Jim and Tammy Bakker, Morton Downey Jr., Shirley MacLaine, and the Home Shopping Channels, things remain the same. Then again, I'm also sure that people had their own brand of silliness to contend with ages ago.

The Johnsons, for instance. Milt and Wendelin, husband and wife, neighbors of Rex and Polly. Married couples across the globe function as tag teams: the spouse of the wife's or husband's best friend gets the crazed notion that the ''best-friendship'' shared by one spouse can be duplicated between the others. In this case, Milt Johnson is the one with the fantasy, and no matter what Rex does to avoid Milt, try as he may, he just can't get away from him. Milt sees Rex as his best friend. Rex has another view of the situation, which is closer to the truth.

Despite her impatience and low tolerance level, Polly, Rex's wife, does truly love her man. For the most

part, Polly rules the roost and keeps a very tight grip on Rex's reins. She continually gives Rex lists of chores to do with the primary purpose of keeping him out of trouble. She also is constantly working on him to try and improve himself. What she fails to realize is that Rex is what he is and will probably never change. Like Popeye, Rex's motto is "I am what I am."

I can only describe Rex's response to situations he gets himself into (and the situations he is put in by others) as very quiet, passive, but apprehensive, acceptance. As though he assumes that, if he is still, perhaps everything will go away. Rex's attitude, his point of reference, is very much reality-based. So much so that it appears to be little off center.

My first encounter with that exact feeling came when I was a boy. My mother and father dropped me off at my grandmother's house so they could do some shopping. My grandmother's name was Mable; she was a very warm-hearted, giving individual who at one time worked the carnivals as a hoochy-coochy girl. She married Frank, the town constable, and managed to make a living taking in boarders. Mostly the elderly, unwanted misfits and folks from the carnival trying to reintegrate themselves into the everyday world.

I especially liked "Wild Bill," who would stand in the kitchen in front of the refrigerator and try to sell me three pitches to knock down the clown and win a glass of milk. Some ex-carnies had a harder time readjusting than others. But their spirits were fresh and alive. Every one of them were proud mavericks.

I remember her feeding me sugar bread (a bowl of milk with torn-up bits of bread in it) or stewed tomatoes and crackers for a snack or lunch. Culinary delights stemming from the fact that Grandma Mable had never forgotten the great Depression, having just barely survived it. It was as common then to serve up these dishes as it is for a member of my generation to, without thinking, buy a box of instant macaroni. (There are still some of us who remember living on tuna, macaroni, and oatmeal all through college.)

Mable always kept the doors and windows shut and the heat turned up so high you would swear you could hear your brain cooking. Now, somewhere in the middle of summer on this one particular day, the two of us sat in her living room for the longest time, not saying a word, just listening to our brains melt, when the clock belted out three. It was a very loud clock that could make the dead jump. Mable turned slowly in my direction and in a whisper said, "Dykie, every day at this time your Grandpa Frank comes down the stairs to check on me and say 'hi.'"

Now mind you, Grandpa Frank had passed away several months before. I didn't know what to say. What could I say, and if I *did* have something to say, would it really matter? I only underwent brain melt in small doses, but Grandma Mable lived in this hot-box twenty-four hours a day. So with a quiet, passive, apprehensive acceptance, I awaited Grandpa Frank's entrance into the room. He never showed up. Grandma Mable and I continued to sit in silence until my parents returned from shopping.

This form of dealing with the world is Rex's safety valve against jumping out of his skin. His way of calling "time out."

I will have to admit that my sense of humor is deeply rooted in my Hoosier upbringing and my love of the older comic actors such as Bob Hope, Red Skelton, Danny Kay, Bud Abbott and Lou Costello. In the area where I grew up in Indiana lived a lot of people who had originally moved up from Kentucky or Tennessee looking for jobs in the factories. These people were jokingly called "Rushins," because they had rushed up North to Indiana on the promise of jobs aplenty. With them came not only the desire to work but also a love of visiting and talking for hours on end. They would talk about everything. To give the conversation color, and spice it up a bit, they would occasionally stretch the truth. Those who had the talent to really flavor the story were my favorites. With the smallest bit of truth as the basis for the beginning, they could look you square in the eye and with conviction, explain that "a cat will, in fact, suck your breath away from you in your sleep. They lost three people here in the county in the last month due to a cat sucking their breath." It made you feel like giving the cat away to a research center. No matter if you liked the cat or not.

The Midwest was rich with people practiced in the art of storytelling and leg pulling. As a people, I think that we have somehow lost this ability. Times are faster. People just don't seem to have time for a leg-pulling session. The Midwest is growing and growing but still a little slower than the rest of the country. There, you can still find a simple, honest approach to life that is quite beautiful. A lot can be learned from it. If you feel bad, you simply feel bad and you deal with it. You go about your day. You don't spend time trying to invent countless reasons for your state of mind. If you're happy, you're happy, and boy, ain't it great.

More and more I discover my upbringing in my work. Fourteen years after moving from Indiana to the Southwest, I find that I'm still a Hoosier and will probably never change. I just wish my accent *would*, however, this strange, lazy pronunciation of words with which I seem to be afflicted.

I've never had what you could call formal art training. In college, I took one art class and was bored and dropped it. I thought a career in folklore or world religion would be secure and profitable (my decision-making clearly should have been more carefully monitered). I have drawn since I was a child. It was never viewed as extraordinary, so I never saw it as anything other than entertainment and knack that allowed me to make friends.

It wasn't until I had moved out West to Denver, Colorado, in 1976 that it was pointed out to me that the ability to create was not inherent in everyone and that what I was a capable of doing *was* actually extraordinary. Shortly after I established myself in the community and adjusted to living in a city, I was in-

troduced to an artist named Frank Howell, who gave me a job selling art in his gallery during the day and picture-framing in his studio at night.

I'm not quite sure how long I had worked for Frank before he saw some of my drawings lying around, but I'll never forget the day that he first noticed them. He called me into his office. (Imagine that—an artist with an office.) Once I was in and the door was shut, Frank proceeded to tell me in a voice that would make a drunk man stand sober that my laziness and blatant lack of self-worth made him sick. I was not excercising my ability, he said.

Up until that time, I had only seen the sensitive artist-poet side of Frank Howell. There in that locked room, the high school wrestling coach, Detroit ghetto high school teacher, and ex-Marine Corps drill sergeant side of Frank Howell was unleashed with me at its center. I would have preferred to have stuck my head in a box of really upset wolverines and taunted them. His words chipped away at my blindness and resistance to the fact that I was an artist. Frank Howell very graciously took me under his wing and began to teach me technique and about the various mediums. He showed me that the brushes, pencils, canvases, and paper were all tools and how to care for them and to understand the potentials and limitations of each.

Most of all, he taught me the discipline of the easel: focus your intent on that which you are and live with it. A strong focus of intent is greatly needed during that period. As time goes on, the focus matures. If you're an artist, be an artist and take responsibility for it. It's easy to take responsibility when times are good, but to take responsibility when times are bad is a trial by fire.

One of the most important things Frank said to me was "an artist's place is in his studio," which means that if you're going to be an artist, you have to work at it constantly. You don't assume it will take care of itself. Treat creativity as a muscle and don't buy into creative block. The education I received while working as Frank's assistant couldn't have been obtained at any school.

This life has its trade-offs. For example, my work day doesn't end until I go to bed at night. There are no paid vacations and there are large emotional and financial commitments. Play is important, but I can't seem to find the time for it. These simple rules make it possible for me to stay at the easel and table for hours on end.

The technique I use is a combination of prismacolor pencil and acrylic paint on canvas. The end product is a result of layer upon layer of drawing and painting. In the beginning, I lay down the drawing of Rex in whatever environment I choose. This is followed by a wash, a thin layer of paint. After this is completed, I apply a coat of medium, which creates a new working surface. Over and over again, this is repeated. With each layer, the drawing becomes more intense and more refined. The first few layers of drawing are like working on sandpaper, but with each new layer, the color builds and the prismacolor becomes easier

to blend. There are some areas in the canvas where only paint is applied. This method involves a lot of time but the end result is well worth it, as it gives the paintings the luminosity I desire. The finished paintings have a technically classical look.

In conclusion, I'd like to join Rex in a sentiment with which I heartily agree: "While Polly vacationed in Palm Desert she insisted Rex go on a vision quest for greater self-awareness. The only thing that entered Rex's mind was that the next time he did this, it would be at a heated lodge with HBO." Rex and I hope you like this book and that it provides you with an amusing diversion.

"Malcom was more than happy to show Rex the way to the dance."

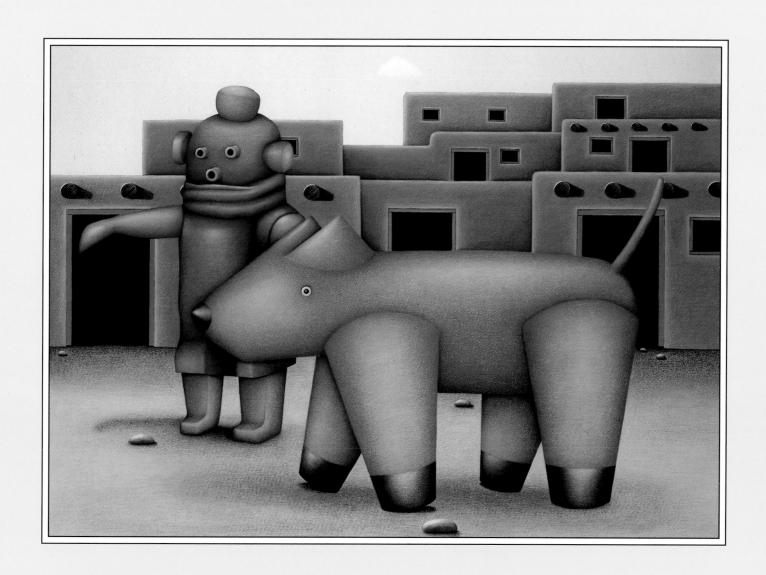

"Rex quickly learns
that visitors are not always
welcome to all the dances
on the pueblo."

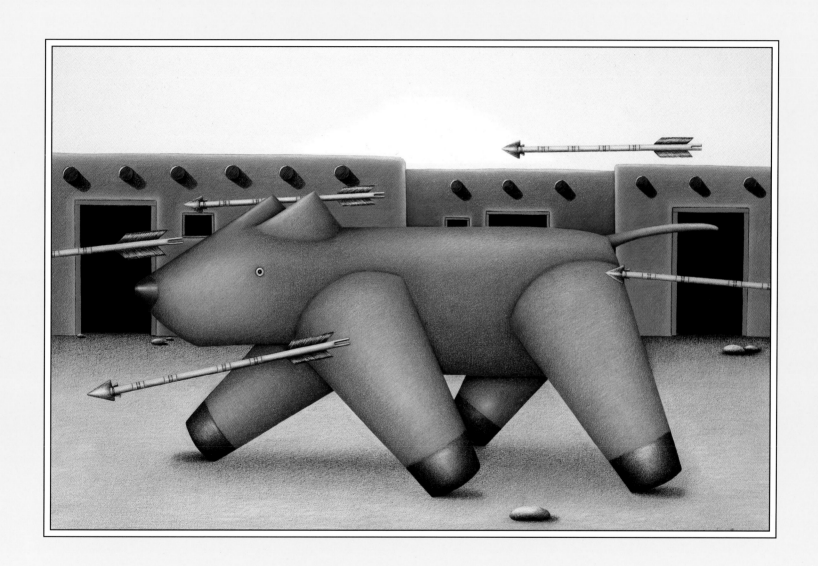

13

"Disguised as a Taos Indian, Rex explains to the tourists that photos are $2 their camera, $5, his."

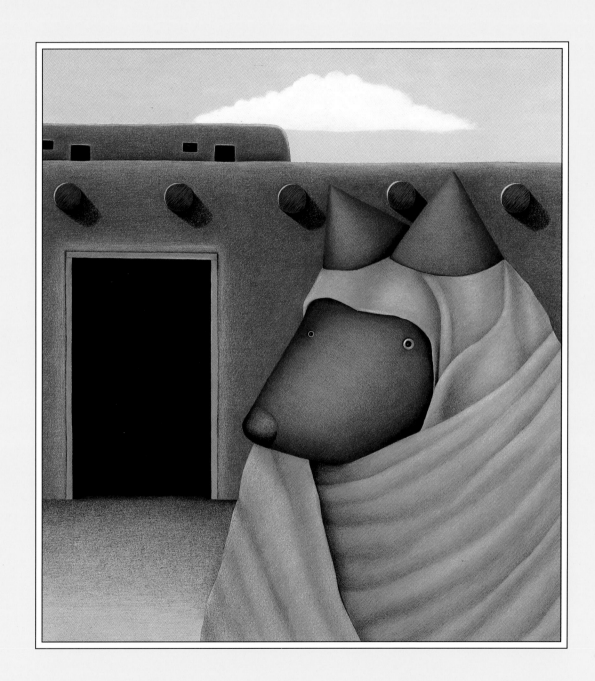

"Knowing Polly and Paloma's love of bread, Rex knew that he would find them at the ovens."

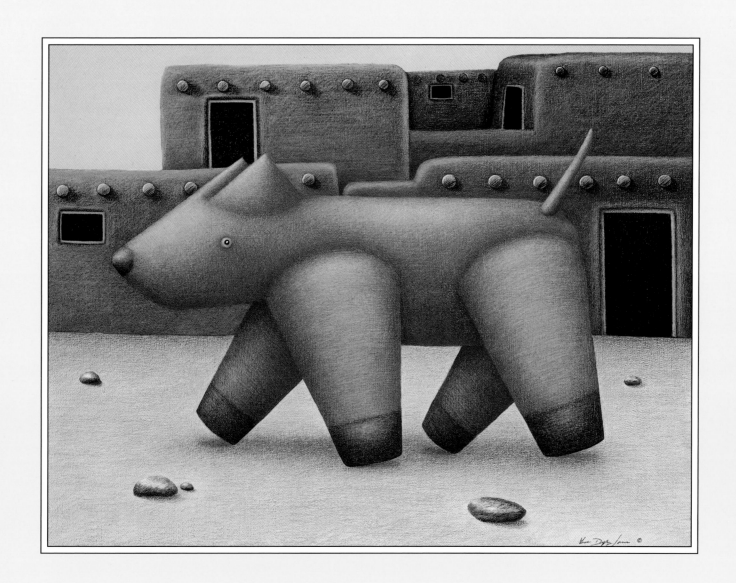

Polly wondered
how many more things
she would have to pose with
before Rex got it right."

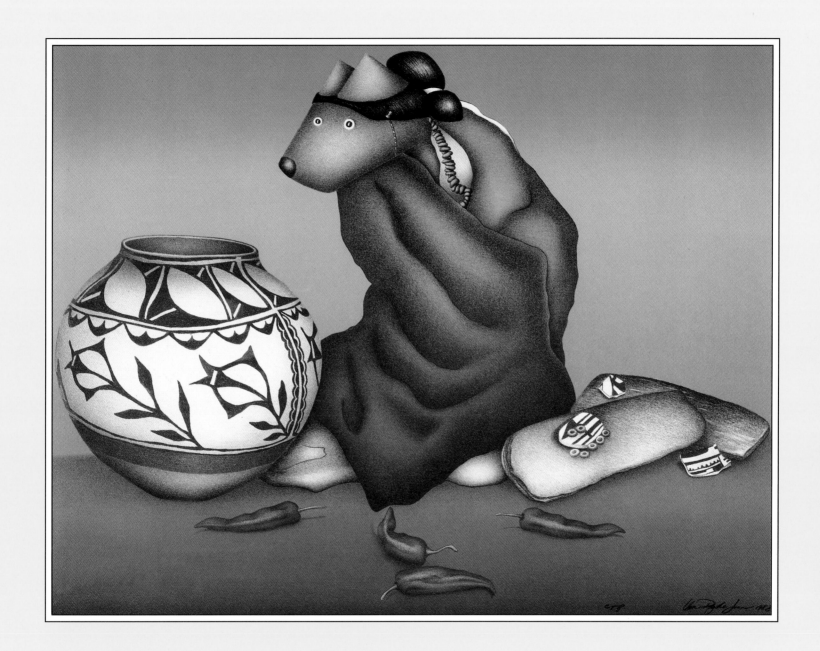

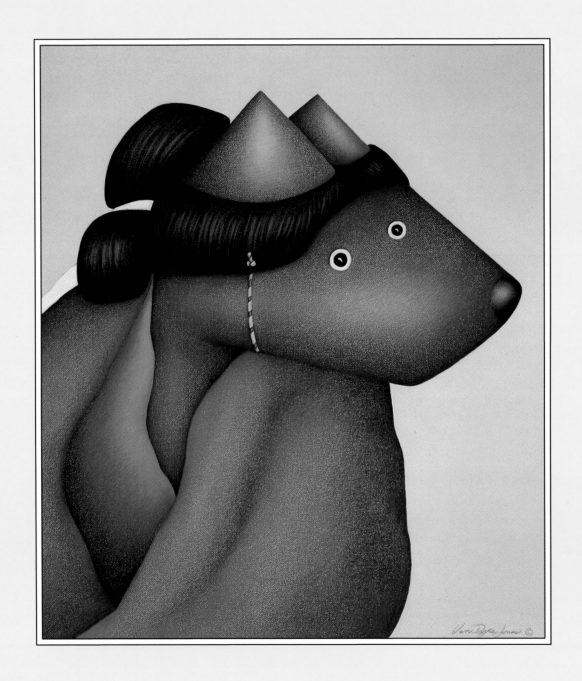

"Litho study of Polly,
Rex's wife, friend, partner in life,
and boss."

"**W**it Rex had a dollar
for every time Polly sent him out
for more party mints
during her weekly get·togethers with the girls,
he figured he would have enough
to buy back New York City
from the Japanese."

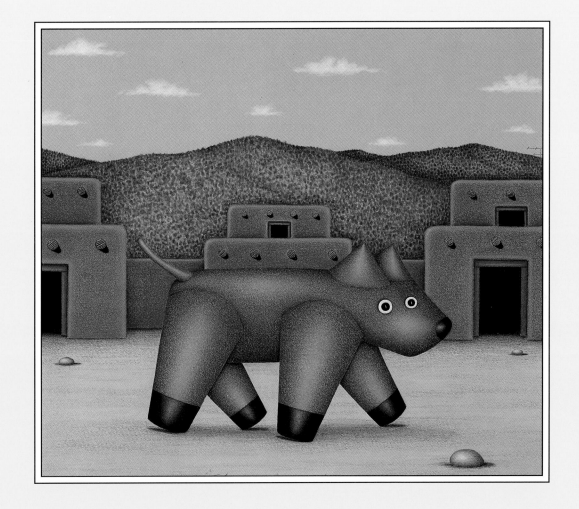

"As the Jehovah's Witnesses approached the front door, Rex made his escape out the chimney."

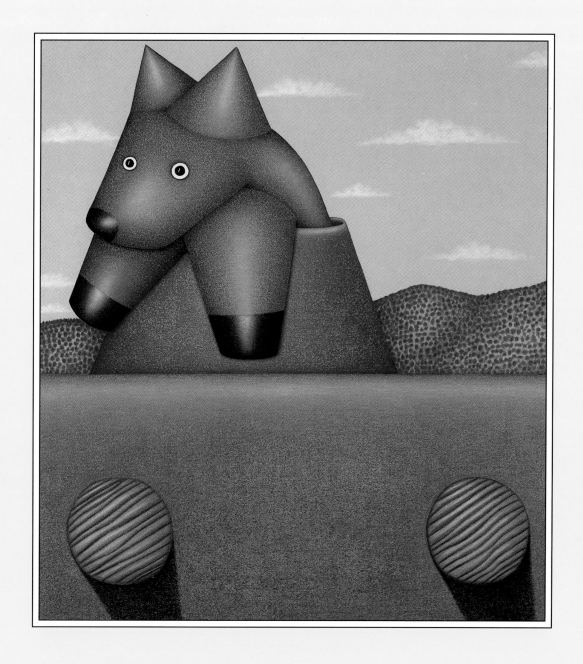

"Rex was surprised
at how understanding Polly had been
when he told her he was going
to the horse track with his friend Tony,
instead of taking her shopping
as he had promised."

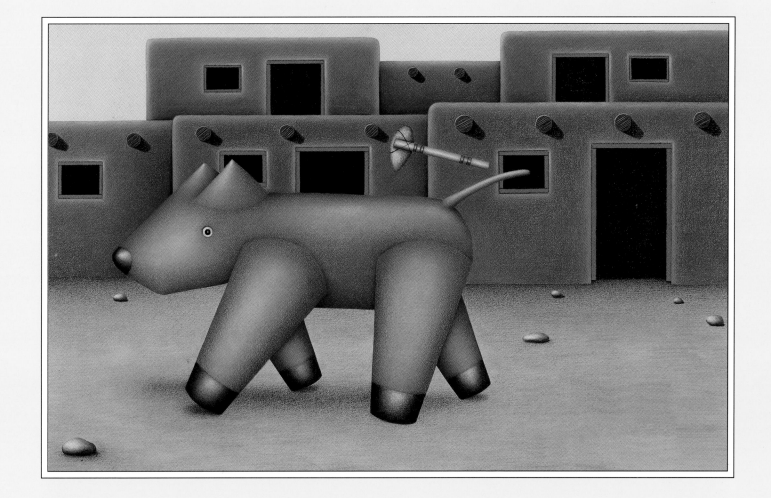

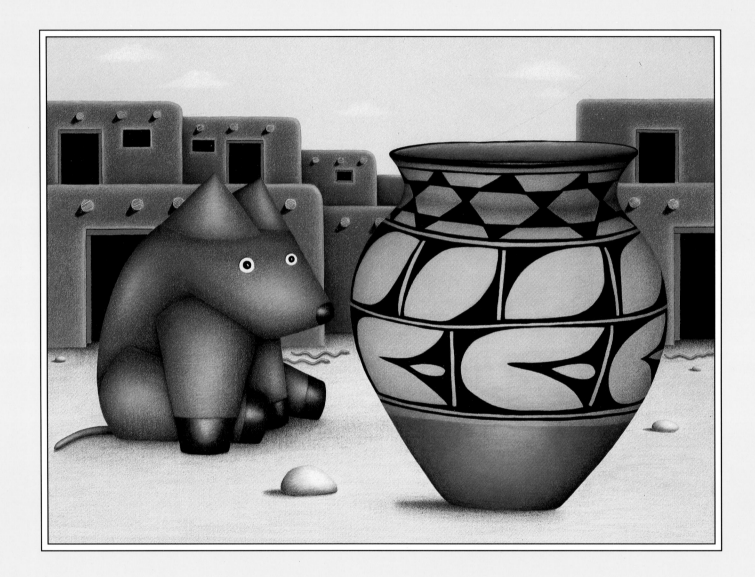

As Rex kept an eye on Polly's pot,
as he had been told,
the Johnsons had enough time
to slide into Rex's house
and eat his lunch."

As Polly left to go shopping,
she reminded Rex once more to
get rid of the hat before she returned home,
unless, of course,
he would rather have it removed
by a team of surgeons at
the emergency room."

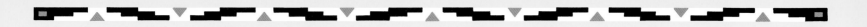

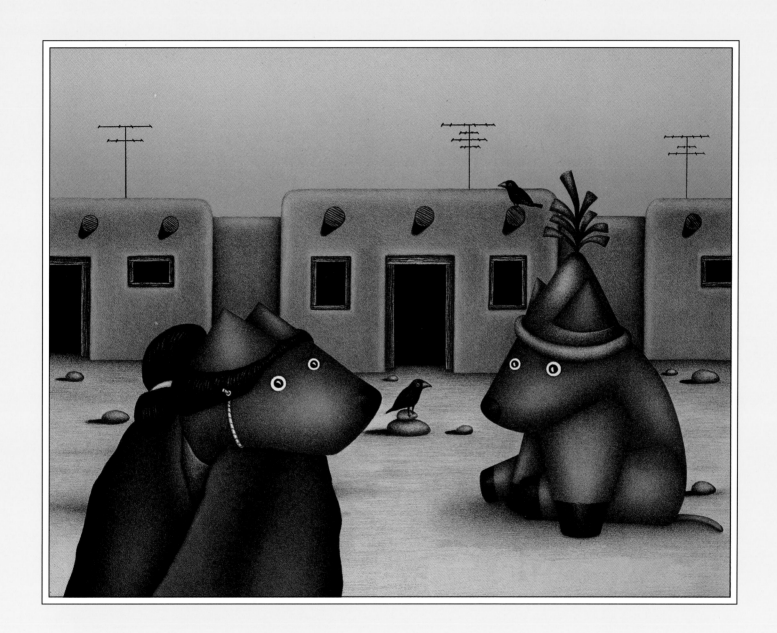

"Rex was sure
that the only reason
Polly had invited the Johnsons
over for dinner was to drive him crazy.
That had to be it."

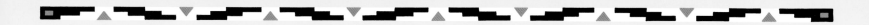

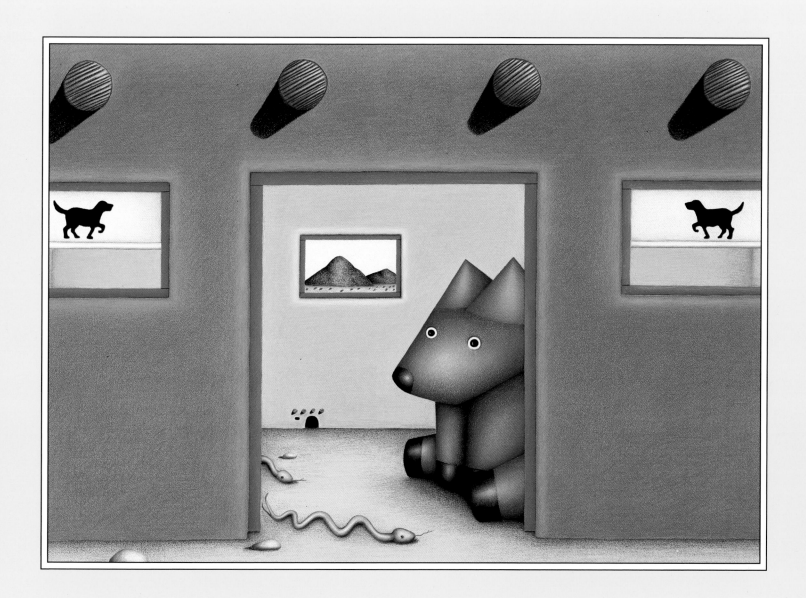

"Rex was reluctant
to perform the Bone Dance,
for he knew only too well of the danger
involved. The last guy was struck
in the head by a falling bone
and lived out the remainder of his life
as Shirley MacLaine's dog."

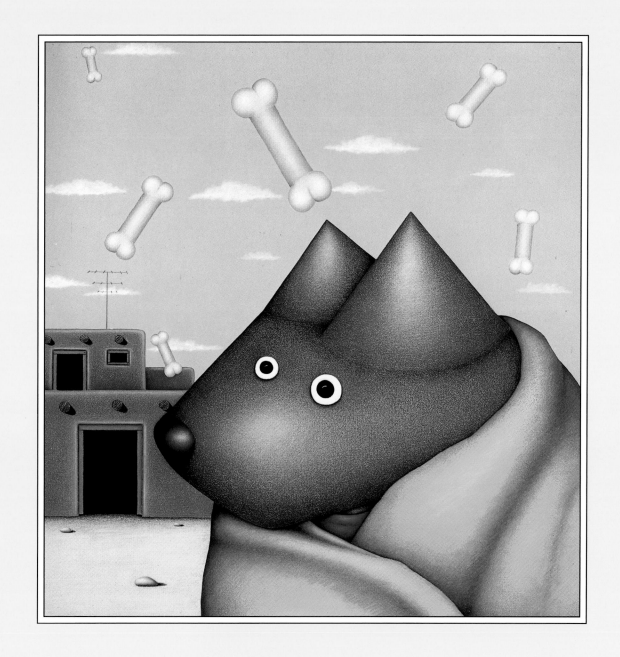

35

And it came to pass,
 after leading his people
 out of the land of the dogcatcher,
 into the land of enchantment,
 there was no food,
 and the people grew restless and angry.
 It was then that Rex heard a voice
 similar to John Huston's
 saying `Look up, boob!'
 and there was food."

"Rex was't about to eat anything that looked as if it had a strong enough memory to wait for him in the next life."

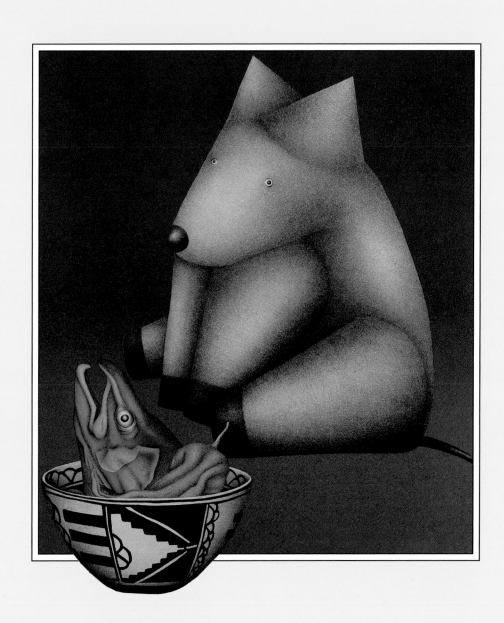

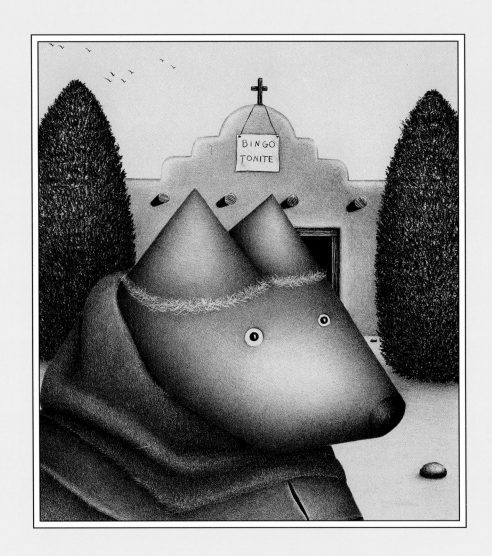

Saint Rex,
Patron Saint of the Silly.
Branded as a heretic for reportedly
giving mass in pig latin, later canonized
as a saint for his contribution to the
game of bingo. Best known for
his book, Bingo Without Guilt."

"Rex's wish when he saw
the first star of the evening was
that he hadn't locked
himself out of the house
on such a cold night."

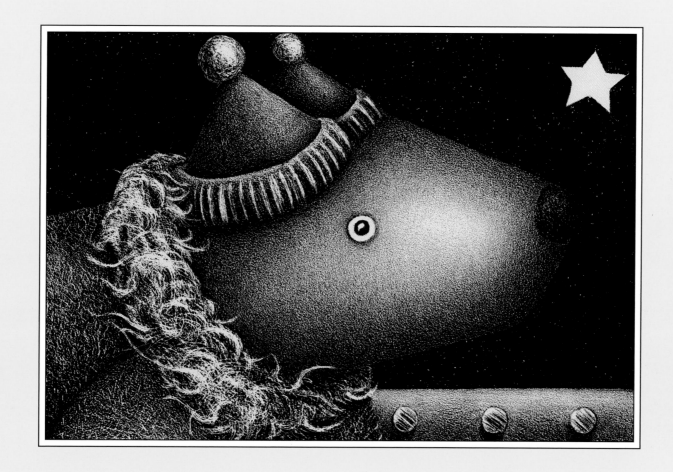

"While Polly vacationed in Palm Desert,
she insisted
Rex go on a Vision Quest
for greater self·awareness.
The only thing that entered Rex's mind
was that next time he did this
it would be at
a heated lodge with HBO."

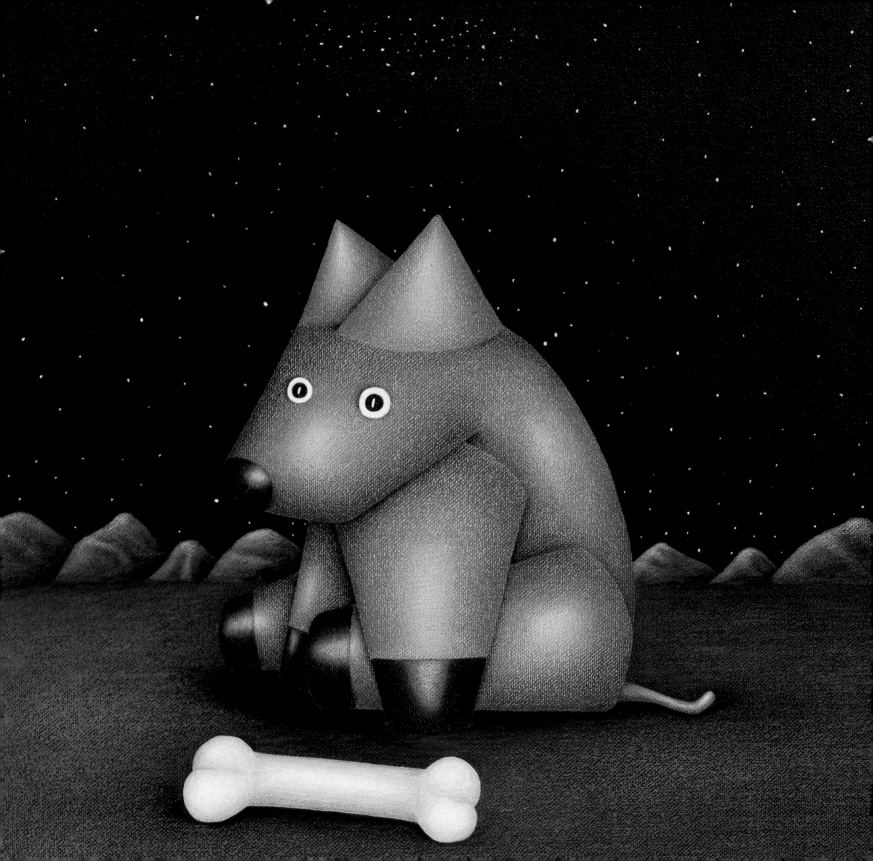

"Rex was faced with the realization that it was quite possible he had lost his mind in agreeing to participate in this two-week self-discovery course out in the middle of nowhere. God, what he wouldn't give for a cup of coffee and a newspaper."

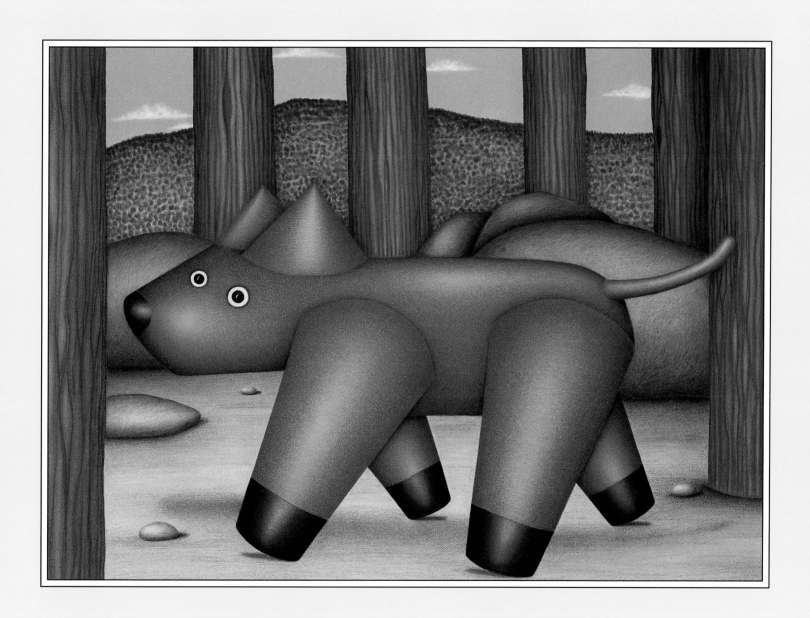

"Rex decided to hide out for awhile
until Polly had enough time
to calm down.
Polly had returned home
from her mother's and found the house
a mess and their daughter Paloma
in front of the TV watching
'World Federation Wrestling.'"

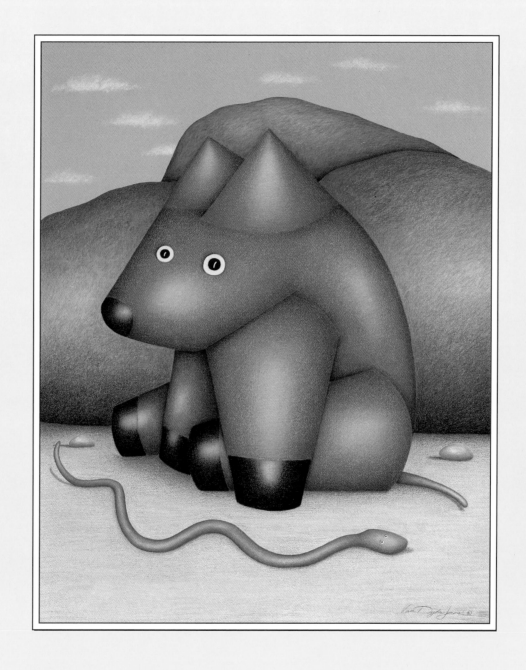

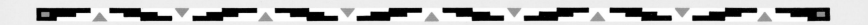

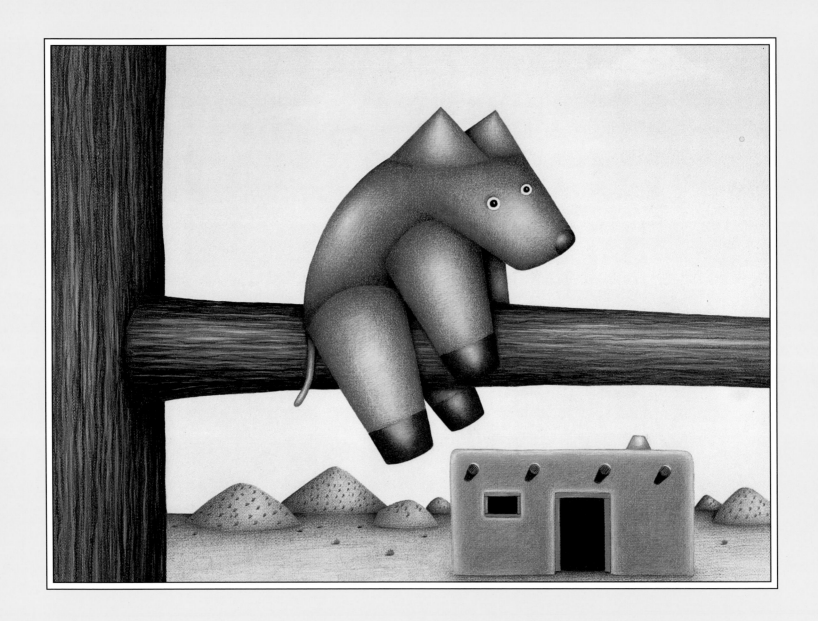

Although excited about the arrival
of his Slim Whitman tapes,
there was no way in hell
Rex was going to be home
when Polly had to accept the C.O.D."

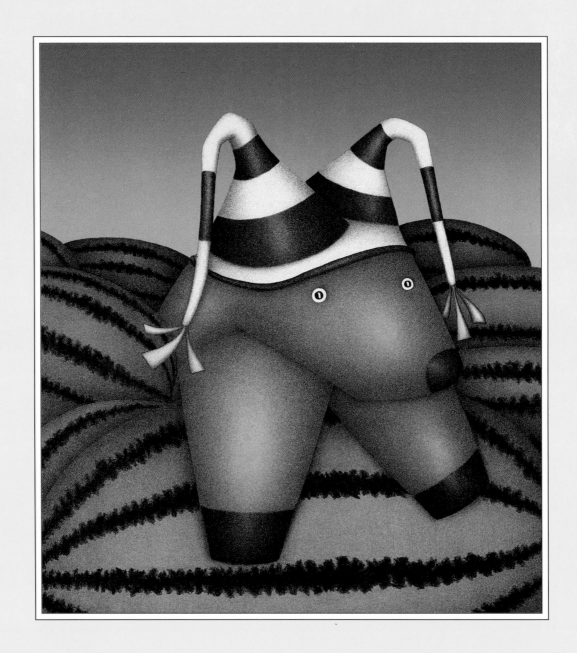

"Watching Polly's reaction
as she accepted the C.O.D. on the items
he had purchased from
the Home Shopping Channel,
Rex could see that he had more time
than he had anticipated to spend
with his melons.
Pity he hadn't brought his sleeping bag."

"After carefully placing the rocks where Polly had requested, Rex decided it was time to rest."

"Rex thought for sure the ad had read 'Lap dog needed,' not '<u>Lab</u> dog needed.' Rex figured it best just to go on home and take another look at the paper for a job a little less demanding."

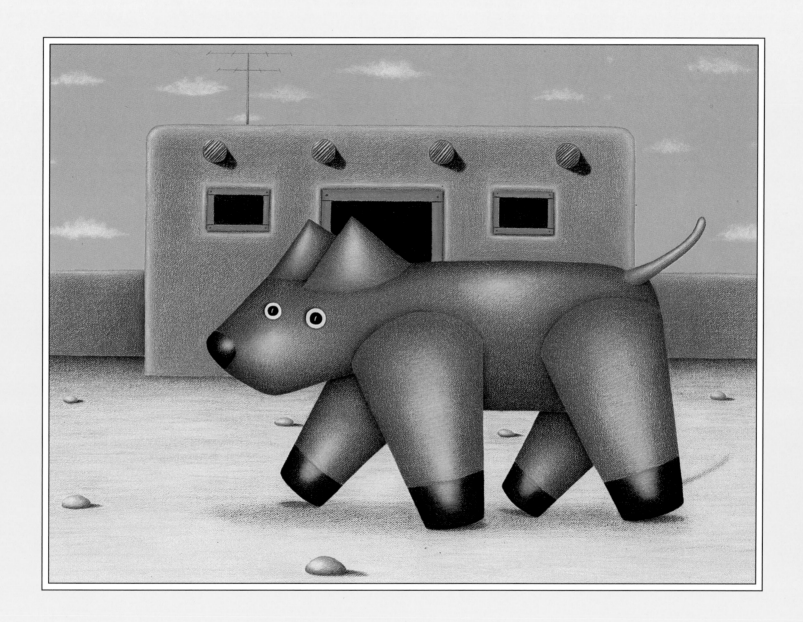

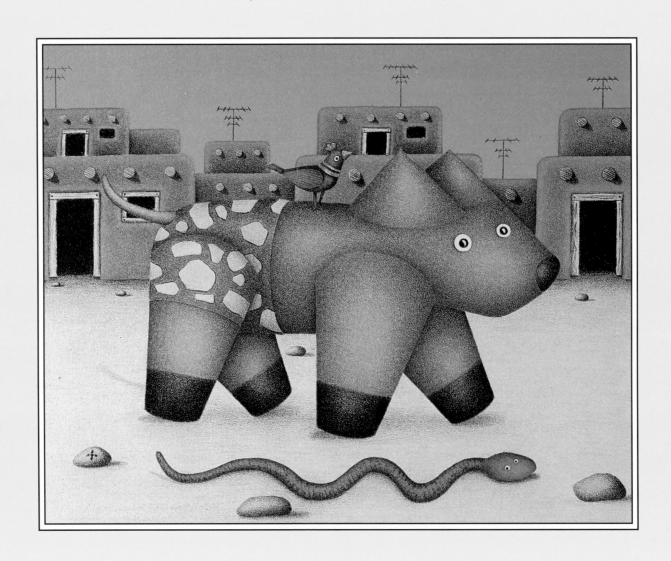

"Rex, with the help of Milt Johnson, frantically searched the neighborhood for Polly's pet bird Rodney before Polly returned home from her karate class."

"Rex and Milt
would just have to take
an old, cold tater and wait until Polly and
Wendelin were finished listening to their new
Mary Kay representative, Myrtle Lamore.
After all,
there are some things
more important than cooking."

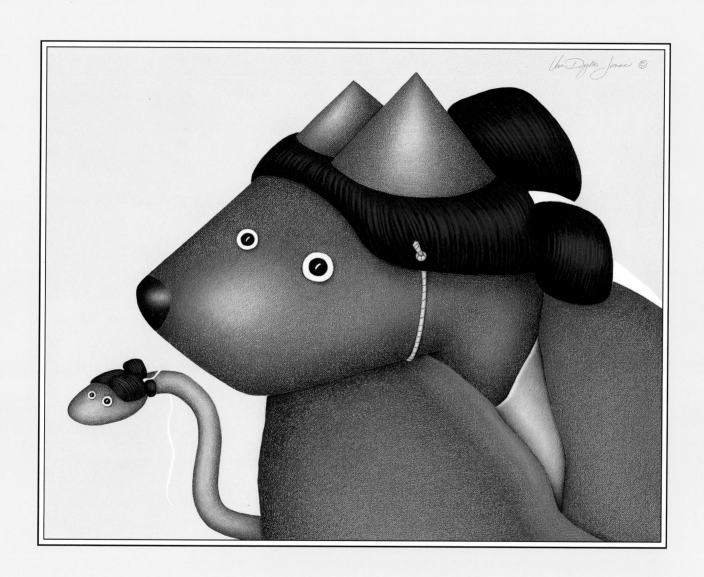

"Rex wasn't about to make the same mistake twice. The last time he ate a chile that size, he had a nitemare that he had sent money to Jim and Tammy Bakker."

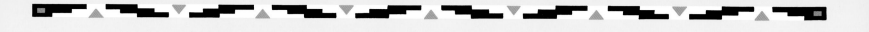

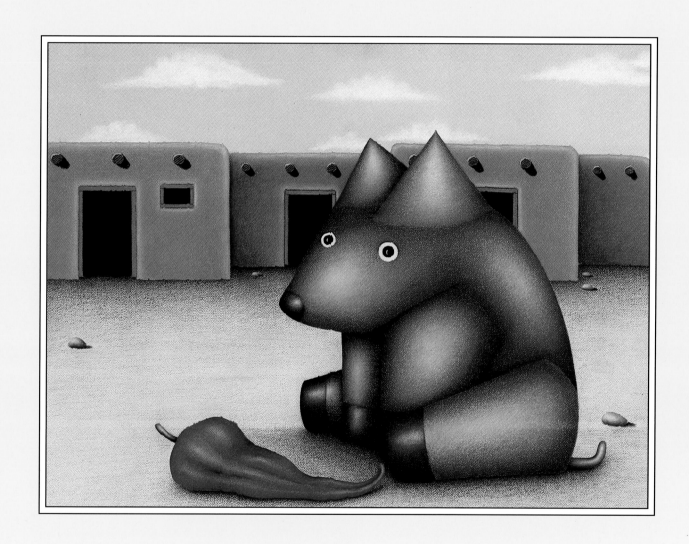

"Rex made sure the coast was clear
of any bible salesmen
before leaving the kiva."

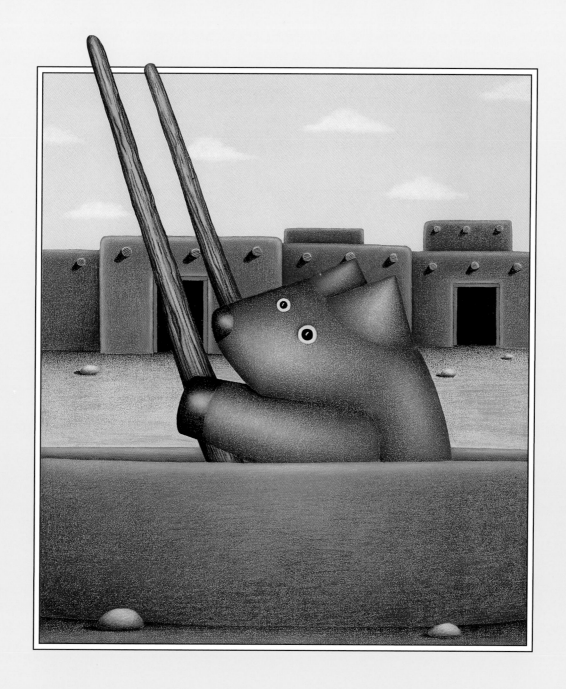

"WHaving made the delivery,
Rex bids farewell
to La Lani What·a·Blob and
the Rocktonians."

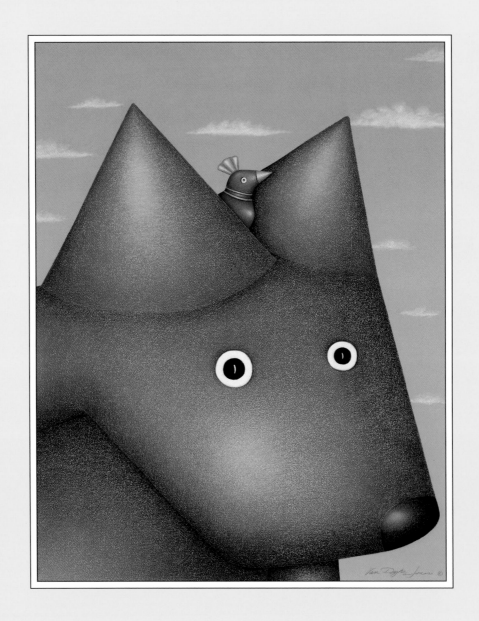

"**Rodney** used **Rex** as a hide·out
after attacking **Tammy Bakker**
to get her eyelashes to make a nest.
Rex really needed this kind
of trouble."

"**R**ex could see right away
he'd have to be more careful
with the phrases he taught Rodney."

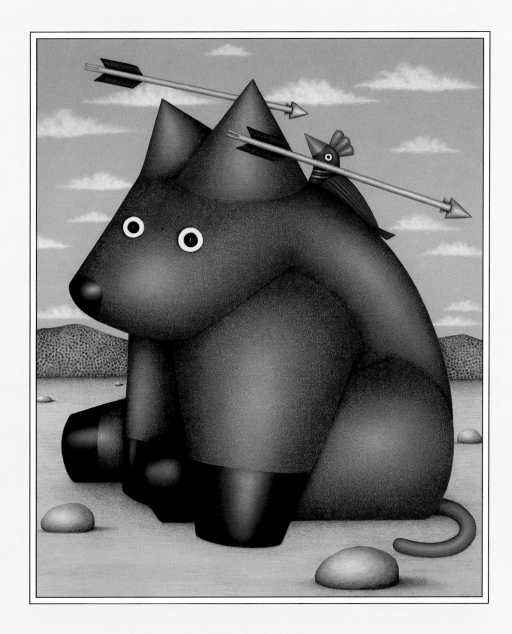

On the way
home from the zoo,
Rex found himself in the middle
of a domestic squabble
after Wendelin caught Milt
in the reptile house
displaying more than academic interest
in a cute little cobra
from India."

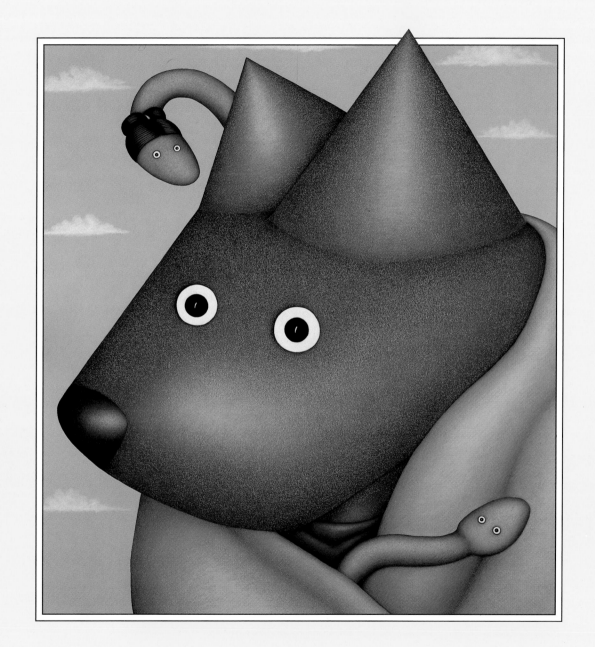

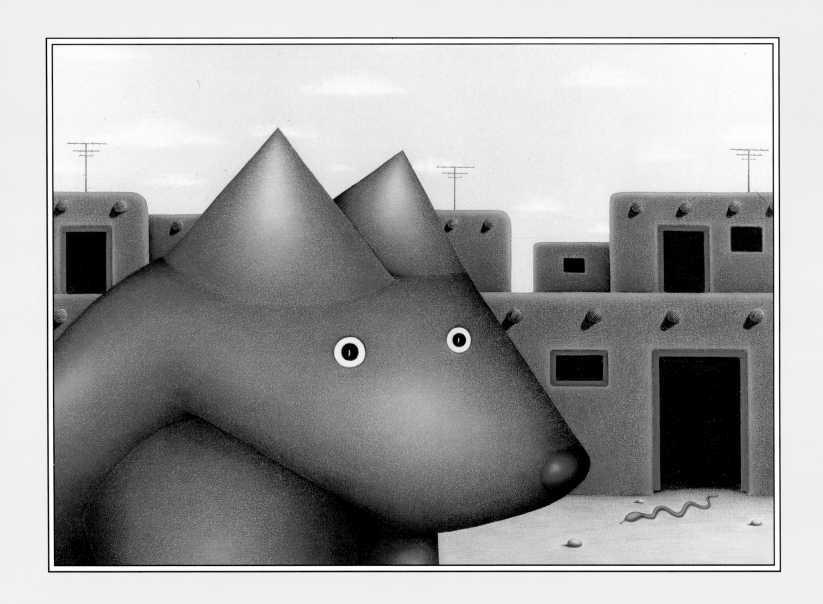

Seconds
from a clean getaway,
Rex is spotted by Milt Johnson
and forced to listen
to more pearls of wisdom from the
Morton Downey Jr.
Show."

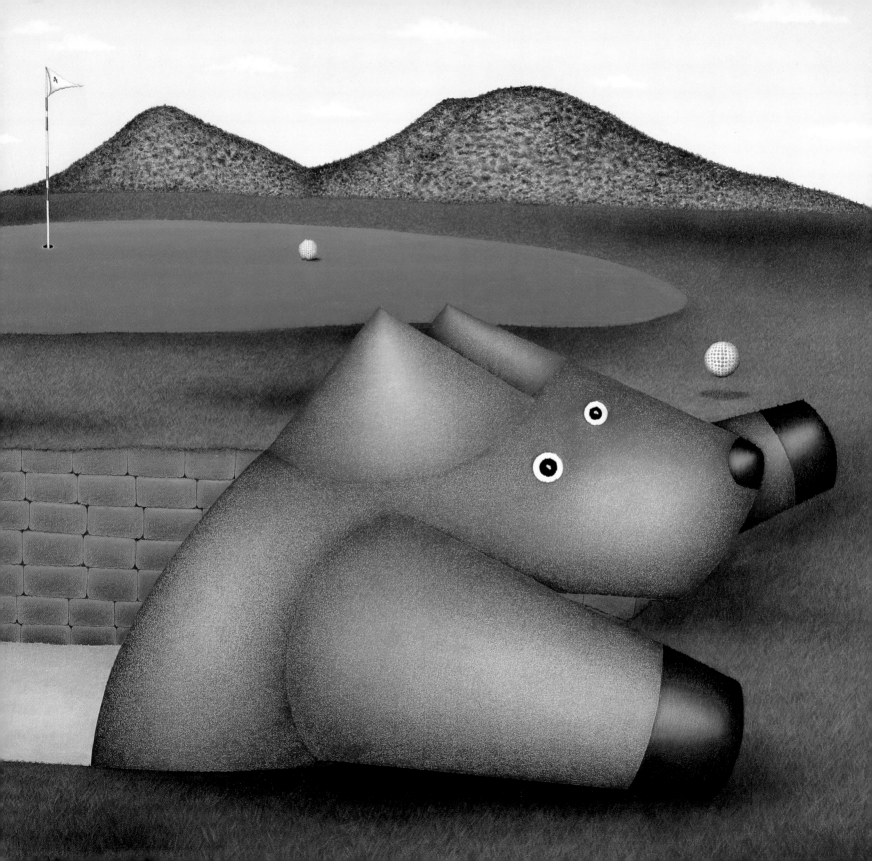

"When
Rex was told
he should visit the Quail Run Kiva,
he had no idea that they were sand traps
on a golf course. He simply assumed
he would be visiting another
Pueblo kiva."

"With the return of
Jim and Tammy Bakker to the air waves,
Raphael knew the only thing
that would cheer up Rex
would be a good game of
'Find the Duck.'"

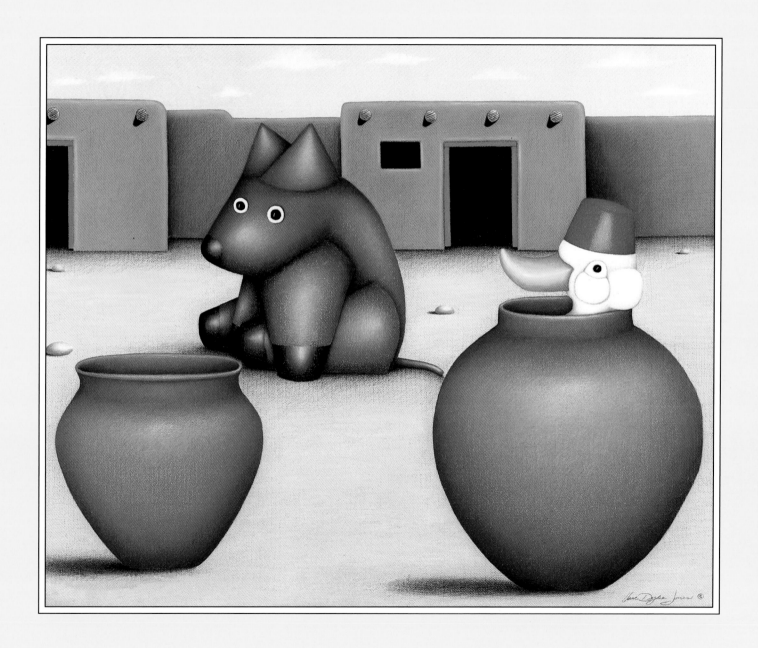

"Rex and Raphael
really didn't care
what others had to say,
they welcomed any opportunity
to wear their hats.
They were just those kind of guys."

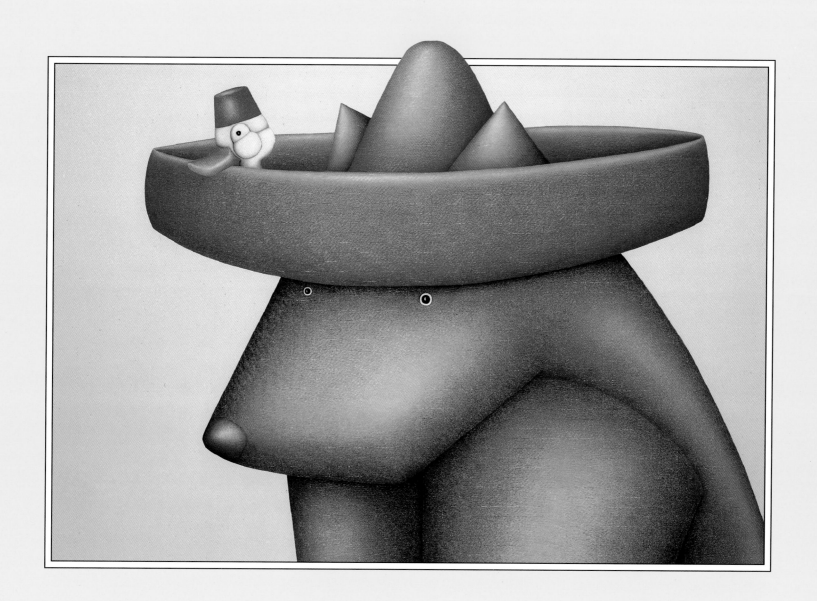

"Upon learning
that their wives had invited
their mothers
to visit for the summer,
Rex and Milt, remembering the experience
of the year before, wasted no time
fleeing to neutral ground."

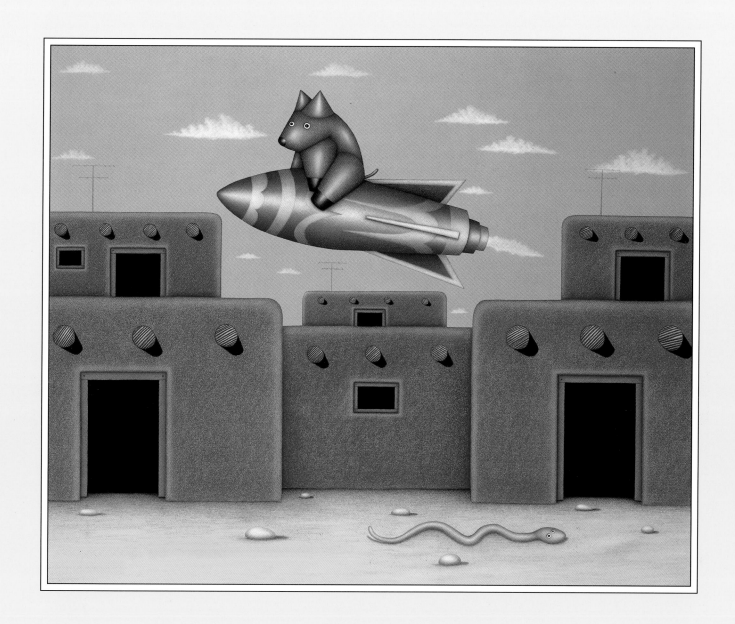

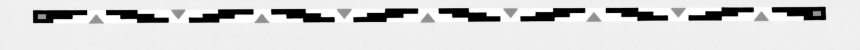

84

"While
Rex's mother·in·law was visiting,
Polly had made it clear
Rex was not to set foot in the house
until he lost the hat.
Rex thanked God he owned the hat...
he could wear it for a month
if he had to."

"Folks often questioned
Rex's sensibilities in his choice
of hats. But then again,
if the hat fits,
wear it."

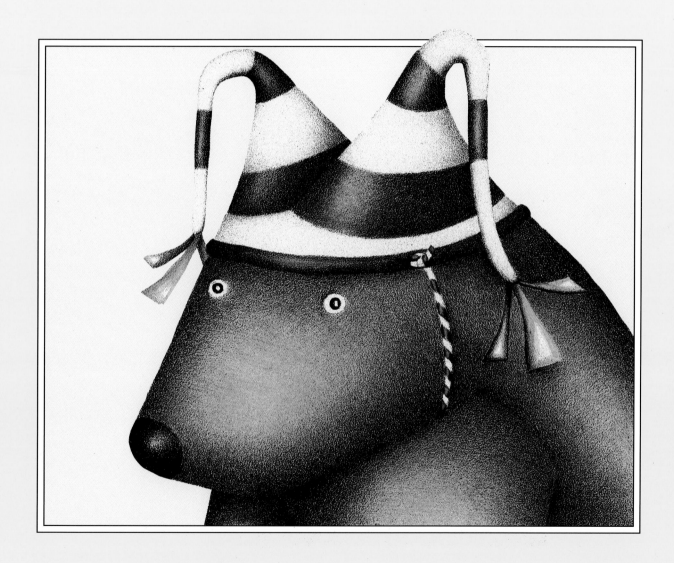

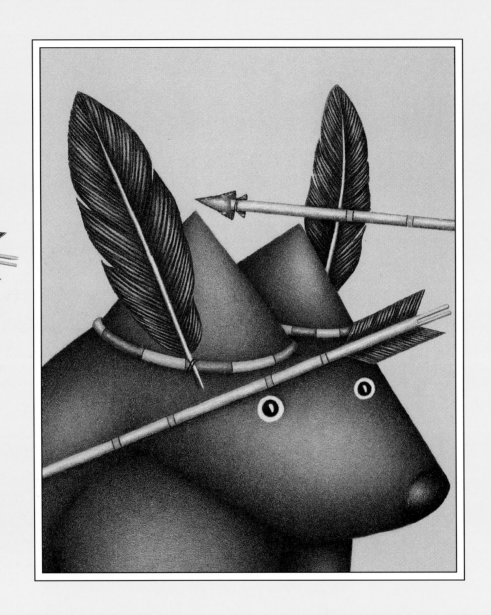

"**Rex** Quick·to·Split
took this to mean 'no'
to his request for traveling expenses
for the upcoming hunt."

As the war party prepared for battle, Rex Quick-to-Split ducked behind the tee-pees and waited until they were gone. Rex made it a point never to get involved in any event more stessful than a spelling bee."

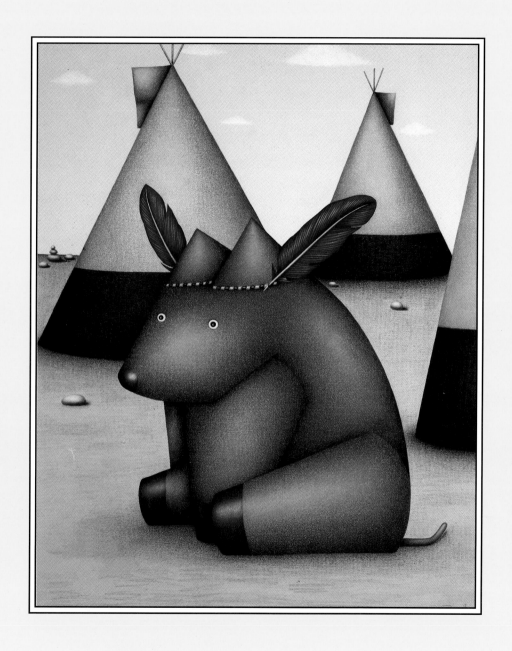

"If it were
anyone other than Rex,
Jack would never allow these
midnite rides."

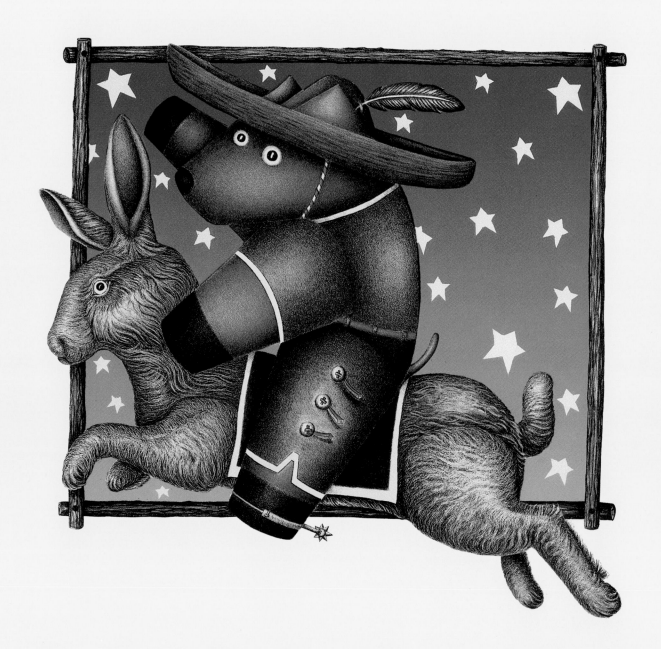

List of the Art *(in order of appearance)*

Following is a selected list of galleries
that carry Van Dyke Jones's
original art and lithographs.

Contemporary Southwest Galleries
Santa Fe, New Mexico
La Jolla, California

Friesen Gallery
Sun Valley, Idaho

Joan Cawley Gallery
Scottscale, Arizona

Moonstruck Gallery
Las Vegas, Nevada

Robert Shields' Fantasy Gallery
Sedona, Arizona

Squash Blossom Gallery
Aspen, Colorado

THE